IMAGES
of America

SUTTER CREEK

This overview of Sutter Creek dates before 1890 and captures the town during the midst of its hardrock heyday. In the background, the Voorheis and Barney Chlorination Works and the Lincoln Consolidated and Mahoney gold mines stand out against the foothills. Main Street's dirt length is framed by tidy businesses and decorated with an arch. At the town's edge, busy streets give way to fenced corrals and outbuildings, pastures, and gardens, moving toward an invisible photographer from a century ago. (Courtesy Amador County Archives.)

ON THE COVER: Expert machinists from the Knight Foundry pose in front of a gigantic, cast-iron pulley made for an ice plant in Sacramento, c. 1902.

IMAGES
of America
SUTTER CREEK

Kimberly Wooten and R. Scott Baxter

ARCADIA
PUBLISHING

Published by Arcadia Publishing
Charleston SC, Chicago IL, Portsmouth NH, San Francisco CA

Printed in the United States of America

Library of Congress Catalog Card Number: 2006929374

For all general information contact Arcadia Publishing at:
Telephone 843-853-2070
Fax 843-853-0044
E-mail sales@arcadiapublishing.com
For customer service and orders:
Toll-Free 1-888-313-2665

Visit us on the Internet at www.arcadiapublishing.com

For Larry Cenotto, Amador County's first archivist.

CONTENTS

ACKNOWLEDGMENTS

Foremost on our list of thanks is Larry Cenotto, Amador County's archivist for over two decades; without his assistance, this book would not have been possible. By the time this volume is published, Larry will have retired after 26 years of invaluable service to his community. Deborah Cook, assistant archivist and local historian, also provided valuable assistance. We'd also like to thank the generous people who allowed us to reproduce their private and family collections, including Paula and Gary Wooten; Jim Wooten, who shared stories of his years spent working at the Old and Central Eureka Mines; Carolyn Fregulia, who has been researching the genealogy of Amador County's citizens for years; Ed and Mimi Arata, who opened their home to us and provided amazing details of the town's history that we literally had not seen before; and finally Ed and Margaret Swift, who allowed the use of a collection Ed has been compiling for years. Georgia Fox, curator of the Amador County Museum, helped start our search with her resources. Paul Sandul generously shared his own publishing experiences. Jennifer Vodden revealed details of historical costume, helping to narrow dates of photos; her expertise is admired and appreciated. Finally, we would like to reach back to all the anonymous men and women who founded Sutter Creek; their hard work and perseverance on what was at one time the edge of civilized society we have come to greatly admire. All of the author's proceeds from sales of this book will be donated to a Friends of the Archives fund to aid in purchasing future collections.

INTRODUCTION

Like many communities in the Sierra Foothills, Sutter Creek grew out of the great gold rush of 1849. Thousands of men of every nationality arrived seeking their fortunes through toil, sweat, and luck. Americans from the East labored next to Chileans, Chinese, Englishmen, and Mexicans. They all came to work the placer deposits of the mountain-fed streams around a location that would come to be known as Sutter Creek. A few succeeded in attaining the vast wealth that had been touted in the pamphlets and stories that had inspired their journeys, but many more failed.

Others quickly turned to more traditional trades, realizing there was more money to be made providing for the miners than there was by mining themselves. They set up tents and erected small cabins to serve as bakeries, blacksmiths, boardinghouses, mercantiles, restaurants, saloons, and the like. These individuals, along with the miners they served, were to become the founders of Sutter Creek.

As early as 1851, some of the miners had identified the source of the loose gold they were recovering from the placer deposits. Known as the Mother Lode, this source was the bedrock in and around Sutter Creek. Miners began to dig deeper into this rock and erected mills to crush the ore and recover its gold. It was soon apparent that the mines were showing no end in their ability to produce. Realizing they were going to be here for a while, local residents began to replace their tents and cabins with proper structures.

As the town of Sutter Creek matured, it changed—sometimes rapidly. Stone, brick, and wood-framed, false-front buildings appeared on Main Street. Heavy industry, in the form of several foundries, developed to support the mines, mills, and fledgling community. The mills and headframes dominated the town's landscape, their stamps pounding 24 hours a day. Men began to send home for their families, and soon the streets were filled, not with just scruffy miners but women and children too. Schools and churches joined saloons and brothels. Farmers and ranchers moved in to take advantage of the rich soil and rolling grasslands cleared of trees by the timber-hungry mines. Devastation also helped to reshape the town. Several times fire leveled much of Sutter Creek's business district, which was always immediately rebuilt and often improved. Much of what stands today was built after the last great conflagration in 1888.

Sutter Creek entered the 20th century with the mines and mills going strong. Samuel Knight's famous foundry was manufacturing heavy equipment that was being shipped as far as Alaska, South America, and Africa. The hills were covered with livestock, orchards, and vineyards. Main Street was lined with neat and tidy bakeries, banks, shops, and even a theater for opera. A new technology that would yet again change the face of Main Street was taking shape. By the 1920s, most of the livery stables and blacksmiths had disappeared in the wake of the automobile, leaving behind gas stations, garages, paved streets, and auto dealerships.

The last mine in Sutter Creek closed in the 1950s, bringing the era of hardrock mining to an end. The Knight Foundry continued on into the 1980s and only reluctantly closed its doors. Agriculture remains strong, with cattle and vineyards vying for space on the rolling hillsides. Today the town is largely dependent on tourism, with thousands coming from around the world again to experience Sutter Creek's rich history.

This *c.* 1949 map detail of the town of Sutter Creek and surrounding communities is from the Amador County Chamber of Commerce. Amador, a long, narrow county, is bordered by the flatlands of Sacramento and San Joaquin Counties to the west, Calaveras County to the south, the mountainous territory of Alpine County to the east, and El Dorado County on its northern border. Situated in the heart of the Mother Lode, Sutter Creek's location begins its story. (Courtesy authors' collection.)

One

MINING

The area around Sutter Creek was the site of one of the earliest gold strikes in California. Prospectors came by the thousands from around the world to this area in the famous 1849 gold rush. Here loose gold deposits were found in the gravel beds of the region's many small streams. Known as placer deposits, these gravel beds were easily mined using spoons, pans, and rockers. Soon the creeks were alive with miners. The early years of the gold rush saw rugged individuals carving out a living in the wild hinterlands of California.

As the easily accessible placer deposits were quickly played out, new technology, more manpower, and, above all, more capital was needed to work the claims. Pans and spoons were eventually replaced by sluice boxes, longtoms, and large hydraulic operations. Corporations were formed to organize funding and labor into a cohesive unit capable of moving tons of earth in search of gold.

While most of the initial activity focused on placer deposits, the source of these deposits was found in the massive quartz veins of the Mother Lode. Miners were soon digging away at these veins with pick and hammer. Hardrock mining was aided by many new technological advances, including blasting powder and air-powered drills, which helped to drive shafts many thousands of feet underground. Like the placer mines, the hardrock mines needed more money and manpower as they went deeper and deeper. Corporations backed by Eastern and European investors eventually took control over the more successful operations. Mines such as the Eureka and Lincoln operated on and off for decades, reaching depths greater than 4,500 feet.

Mines provided the foundation on which Sutter Creek was built, economically and socially. When the mines boomed so did the town, and when returns were low so was the mood in Sutter Creek. While the mines provided a few with amazing wealth, for most it was a stable source of income on which to bring families from back East or from around the world. This reliable but difficult work also had a tragic side: fires and cave-ins were not uncommon, and many local families were acquainted with the sorrow of having lost a loved one to the mines.

The 20th century saw mining fortunes rise and fall around Sutter Creek. World Wars I and II brought temporary closures of the mines. The Great Depression had the opposite effect, as out-of-work families began to rework the old deposits in the hope of scraping out a living from their meager returns.

The Central Eureka Mine, the last operating hardrock mine in Sutter Creek, closed in 1958. So ended an industry that for over a century had kept men employed digging ever deeper in the search for gold. Though the mines are closed, reminders of this once-thriving industry are found everywhere. The headframe of the Central Eureka Mine towers against the skyline, the foundations of the Emerson Shaft of the Wildman Mine sit alone on a slope of tall grasses, and the creeks and hills themselves have been sculpted by untold thousands of miners in their search for gold.

Depicted in this lithograph from an 1873 illustration by T. W. Knox for *Underground or Life below the Surface* is a typical placer mining scene during the California gold rush. Displayed are the miner's simple accoutrements, including pick, shovel, pan, pack, tent, and gun. Everyday household items such as buckets, pans, and spoons were enlisted, modified, and put to the task of finding gold. (Courtesy Amador County Archives.)

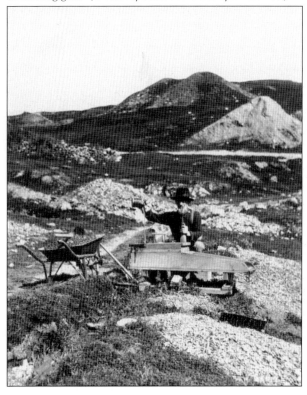

Pictured c. 1900 is Edward B. Oneil of Sutter Creek. He is apparently reworking some previously mined placer deposits. Though 50 years after the initial rush, Oneil is seen here using a tool known as a rocker, which was typical of the mid-1800s. (Courtesy Amador County Archives.)

MINERS AROUND THEIR CAMP-FIRE.

From an 1873 illustration by T. W. Knox for *Underground or Life below the Surface,* this lithograph depicts a gold rush mining camp that could have easily been Sutter Creek. The log cabin was an improvement over a tent, but cooking was still done over an open campfire. Picks, shovels, and pails made up much of the miners' tool kits. (Courtesy Amador County Archives.)

Hydraulic mining proved a more effective form of placer mining. The water cannons, called monitors, rapidly washed away whole mountains to reach the rich placer deposits. The soil and water were then passed through sluice boxes or longtoms to separate the gold from the rest of the soil. (Courtesy Amador County Archives.)

DREDGING FOR GOLD NEAR Sutter Creek

Dredging was another form of placer mining. The dredge generally served as the excavator and mill all in one. The dredges most people are familiar with are the massive floating barges that plied the rivers and flatlands of the Central Valley. This little "Doodlebug" dredge worked the waters of Sutter Creek during the 1950s. In this case, a diesel-powered bucket line dredge excavated the gold-bearing sand and gravel. It was then dumped through a grate, known as a grizzly, to remove the large stones and debris. The smaller particles that passed through the grizzly were then run through a sluice box to collect the gold. The soil was then discharged out of the back of the dredge on a conveyor belt. (Courtesy Ed and Margaret Swift.)

LINCOLN MINE
SUTTER CREEK, CAL.

The first hardrock mine in Sutter Creek was the Amador Quartz Mine No. 2 claimed by Harrison Drew, E. B. McIntire, Samuel and Levi Hanford, and R. C. Downs in 1851. They soon had the town's first stamp mills running. It was consolidated as the Union Mine in the mid-1850s. Though reputed to have produced $2 million in ore, the mine was bankrupt in 1859. This same year, the mine was sold to Leland Stanford, of railroad fame, who renamed it the Lincoln Mine and operated it with great success until 1873 when he sold it to European investors. After the dawn of the 20th century, it was consolidated with the Wildman and Mahoney Mines to form the Lincoln Consolidated Mine. This view of the mine is from the early 1900s. (Courtesy Amador County Archives.)

In this c. 1878 portrait of the Lincoln Mine crew, several of the miners hold candlesticks, their only source of illumination underground. In 1873, nine men were killed at the Lincoln Mine when they broke through to an abandoned shaft that had filled with water and bad air. The air was so lacking in oxygen that the candles would not burn. Four miners were trapped 500 feet down the mine, and after two days of pumping out the water, the four were finally rescued. In recent decades, a new decline tunnel has been driven towards the Lincoln Mine from the direction of Amador City and a test-boring program implemented over the hillside. Expectations are that when the price of gold is high enough, the Lincoln Project will reopen; currently it opens its inner workings for guided tours. (Courtesy Amador County Archives.)

The Wildman Mine was located in the general vicinity of the city parking lot, east of the town's current post office. It was named after its proprietor, W. T. Wildman, in the 1860s. Wildman had many interests and left the mine idle for many years. In the late 1880s, the Boston-based Wildman Gold Mining Company purchased the mine and reopened it. It is from this later period that this picture probably dates. Many of the buildings have been conveniently labeled on the face of the picture. The Wildman Gold Mining Company also acquired the adjacent Mahoney Mine, renaming the operation the Wildman-Mahoney. In 1898, they sunk a new shaft, called the Emerson Shaft, behind the Sutter Creek Grammar School. (Courtesy Amador County Archives.)

In this portrait of the Wildman Mine crew, several men are holding large hammers known as doublejacks. The doublejack was used for hammering drills into the rock into which blasting powder, nitroglycerine, and later dynamite were placed to blow apart the rock. The doublejack required the use of both hands, so a second man would hold the drill in place while the first struck it. Short-handled hammers known as singlejacks required only one hand, so a single miner could drill a hole. (Courtesy Amador County Archives.)

A Wildman Mine crew poses in front of the company's wooden hoist works. While it operated, the complex of mine buildings, including the hoist, was a prominent feature of downtown Sutter Creek. (Courtesy Amador County Archives.)

Here the crew of the Wildman gathered on the pile of timbers used as supports in the mine. Note the hobnail boots worn by several of the men. The only person identified in the photograph is the man in the center with the derby hat, Edgar Field. The young boys in the photograph may have served as apprentices in the surface workings, sorting ore or other simple tasks. It is unlikely they would have been exposed to the dangerous conditions the underground miners faced. (Courtesy Amador County Archives.)

The hoist works and ore bin of the Wildman Mine appear to be fairly new, indicating this image

was probably taken in the late 1880s. (Courtesy Amador County Archives.)

Of all the photographs of mining crews in Sutter Creek, those of the men who worked the Wildman Mine are most prolific. Note that some miners still have candlesticks while others have oil lamps mounted on their hats. (Courtesy Amador County Archives.)

The men in this photograph, dated 1895, were simply identified as "Staff of the Wildman Mine." Look back at the other images of the Wildman crew and note the white-bearded man in each photo. Are any of the other faces familiar? Most of these images are undated and the men unidentified, but they appear to have been taken over a period of time based on noticeable changes in technology and the ever-growing length of individuals' beards. (Courtesy Amador County Archives.)

WILDMAN MINE, SUTTER CREEK, CAL.

Though reportedly a productive mine, the Wildman operated intermittently. Idle in 1867, it reopened in 1887, closing again in 1912. During its operation, the Wildman Mine and the adjoining Mahoney produced about $15 million in gold. All that still stands of the Wildman today is the powder house on Gopher Flat Road, the stone foundations of the Emerson Shaft, and the distinct smell of sulfur emitting from the downtown shaft. In 1906, the Lincoln Consolidated Company purchased the Wildman-Mahoney Mine, adding it to their holdings of the Lincoln Mine. (Courtesy Amador County Archives.)

The Mahoney Mine was located just north of the Wildman. The land it was located on was originally owned by Alvinza Hayward, who sold it to Jerry Mahoney in the 1850s for $1,000. Jerry Mahoney had almost immediate success and quickly sent for his four brothers in Ireland to come help him in the mine. Unfortunately for the Mahoney brothers, they all acquired consumption and died one after the other in the span of a few years. (Courtesy Amador County Archives.)

19

With the death of the Mahoney brothers, ownership of the mine passed to the Mahoney heirs. By 1894, the Mahoney had been acquired by the Wildman Mining Company. They apparently greatly expanded the operation, including the addition of a 40-stamp mill. (Courtesy Amador County Archives.)

A. Menke stands in front of the hoist works of the Mahoney Mine with a pick in hand and an oil or carbide lamp on his hat. Menke is surrounded by the massive timbers used to shore up the mine. (Courtesy Amador County Archives.)

In this photograph, a crew of the Mahoney Mine poses in front of the hoist works. The men are dressed for work with their hobnail shoes and candlesticks in hand. The skip is almost in position to dump ore into the ore bin. Though some mines had ladders built into the timbers of the shafts, most miners used the skips to get down to the workings. (Courtesy Amador County Archives.)

In 1906, the Mahoney Mine, along the Wildman, was sold to the Lincoln Consolidated Mining Company. The company sold the mine to a Duluth-based firm in 1914. Like the Wildman, the Mahoney did not see much activity in the 20th century, having ceased operations after the second decade. This view shows the Mahoney mill in a state of disrepair after its abandonment early in the last century. (Courtesy Amador County Archives.)

The reduction factory pictured above was established by Converse Garland as the Sutter Reduction Works. The business was quickly taken over by Garland's nephew, E. C. Voorheis, after he arrived in Sutter Creek in 1877. By 1879, Voorheis had joined with business partner Earl Barney, and the operation was soon known as the Voorheis and Barney Chlorination Works. The buildings of the reduction works were situated conveniently near the Lincoln Mine, one of its main customers, on Tucker Hill. The chlorination process, developed in Czechoslovakia in 1848, dealt with arsenical ores from which gold was difficult to extract. The ore at the Voorheis and Barney Chlorination Works probably went through the typical process: first it was roasted, which oxidized it, and then it was treated with chlorine gas. The result was a water-soluble gold chloride that could be precipitated using other chemicals. This overview of the chlorination works looking southwest over Sutter Creek shows the desolate landscape of the period, devoid of vegetation, with a dense haze hanging over the town. (Courtesy Amador County Archives.)

The new Voorheis and Barney Chlorination Works is still under construction, with scaffolding surrounding the exhaust stack. Note the barrels on the roof ridge, which were filled with water and could be dumped over the roof in case of fire. (Courtesy Amador County Archives.)

The 1890 Sanborn Fire Insurance map shows the Voorheis and Barney Chlorination Works up and running on the "Road to Amador." The facility is described here: "In operation night and day. No watchman. Buildings substantial and tidy, roof painted with metallic paint . . . Electric lights and kerosene oil lamps. 5 employees." The bleaching tubs and roasters can be seen in the main building, and a blacksmith shop is located to the right. By 1912, Voorheis and Barney's operation was no longer included in the insurance mapping, likely indicating it had ceased operations. (Courtesy Ed and Mimi Arata.)

This photograph, possibly taken for promotional purposes, shows a glimpse into the interior of the Voorheis and Barney Chlorination Works. The exact task the worker is performing is unknown, but he is using ironstone pitchers and washbasins, items common in most any home at this time. (Courtesy Amador County Archives.)

Patented 1918
Will be pleased to give any further information desired.
Manufactured by
SANITARY SEWAGE DISPOSAL CO.
1325 Jefferson St. OAKLAND, CAL.

MINE SEWAGE SANITARY DISPOSAL
Long Needed System Perfected
Specially Desirable for Contractors, Shipbuilders
and Railroad Work

Aside from milling practices, other technological innovations were underway as well. As the mines went deeper, getting into and out of the mine became more of a time-consuming feat that was often quite dangerous. Miners took their lunches and drinks with them, but there were other daily needs that required a little more innovation. The Sanitary Sewage Disposal Company of Oakland developed one device to meet the physical needs of the miners. These were euphemistically called honey wagons. (Courtesy of Ed and Margaret Swift.)

"New Head Frame" - Old Eureka Mine
C. E. Mining Co

The Eureka Mine, generally referred to as the Old Eureka Mine, was established in 1851 on the south end of Sutter Creek. The mine soon erected Sutter Creek's second mill. When it became apparent that the load from the Badger, the Eureka Mine's neighbor on the north, was continuing southward, Alvinza Hayward bought the Eureka out. Hayward eventually consolidated the Badger and Eureka Mines into one operation known as the Hayward Mine or Amador Mining Company. It became one of the most profitable mines in the area, producing some $12 million in gold from as deep as 1,700 feet. The Old Eureka Mine changed hands several times until the infamous Hetty Green took control and shut it down in 1881. It remained idle until Green sold it in 1916. By 1924, the Central Eureka Mining Company had purchased the Old Eureka, eventually integrating it into their other workings. It was during this last phase of operation that this new headframe was added, with round metal ore bins replacing the older wooden ones. From 1930 on, all gold came from the earliest Hayward Consolidated mine shafts. (Courtesy Amador County Archives.)

25

At the Old Eureka, skips were lowered down an inclined shaft by the headframe to the workings below ground. The skips dumped the ore in the wooden ore bins at the base of the headframe. These wooden ore bins are an earlier technology that predate 1924, when the Old Eureka and Central Eureka Mines merged. (Courtesy Amador County Archives.)

The miners are attired in work clothes, including hard hats and carbide lamps, in this 1937 photograph of the Central Eureka crew in front of the Old Eureka shaft. Often the men worked 12-hour shifts at the mines, which ran 24 hours a day and seven days a week. Men working long hours together below ground formed strong friendships that lasted through good times and hardships. It was not uncommon for other miners to help with the funeral costs of a lost miner. (Courtesy Amador County Archives.)

This aerial view of the Old Eureka Mine shows the layout of the mine and its location on the south end of Sutter Creek. The road making the sweeping bend in the bottom of the photograph is Highway 49, and the road intersecting it is the original road to Jackson. (Courtesy Amador County Archives.)

The Summit Mine, closer to modern-day Sutter Hill (then known as the community of Summit), was reactivated in 1895 as the Central Eureka Mine. This 19th-century crew portrait is from the Summit Mine period of operation. (Courtesy Amador County Archives.)

This early image of the Central Eureka Mine shows a wooden headframe and outbuildings. (Courtesy Amador County Archives.)

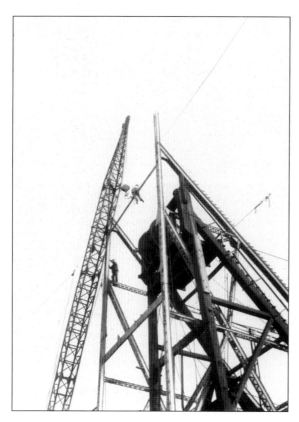

In 1924, the Central Eureka Mine was given an overhaul. Part of this overhaul included a new, more substantial metal headframe, pictured here under construction. (Courtesy Amador County Archives.)

This image from a 1929 annual report shows the battery floor of the Central Eureka Mill. To the left is a bank of eight mills with at least four stamps each. The stamp mills were built by the Knight Foundry of Sutter Creek. Ore was fed into the stamps from the back. The pipe running across the front of the stamps is fitted with nozzles that sprayed water into the stamps. This simultaneously kept the dust down and helped turn the pulverized ore into a slurry. The slurry then exited the stamps and flowed over the concentration or amalgamation tables in front. (Courtesy Ed and Margaret Swift.)

In this c. 1929 view of the hoist machinery room of the Central Eureka, either the machinery was brand new or was kept very clean by the operators. The large electric motor to the left powered the hoist works. The large, wagon wheel–shaped objects above were gauges that let the lift operator know what level the skip was on. (Courtesy Ed and Margaret Swift.)

Many thousands of feet of track were laid down in the Central Eureka Mine for traveling by the familiar ore carts so often portrayed in hair-raising adventures of the small and big screen. Some were pushed by hand, others were pulled by mules, and some were pushed or pulled by small locomotives. Early locomotives were steam powered and later operated with internal combustion engines. These presented a problem in that the exhaust tended to linger in the shafts and tunnels, fouling the air. The favored option was the electric locomotive like the one shown here. The carts were pushed to the main shaft, and the ore was dumped into bins and then hauled to the surface in the skips. (Courtesy Amador County Archives.)

This pumping station was situated 2,000 feet below ground at the Central Eureka Mine. The mines were troubled by a constant inflow of water, making pump stations such as these necessary. The pumps had to be kept in constant operation or the mines would rapidly fill with water. This pump happens to be powered by a large electric motor, though others were powered by steam, compressed air, or internal combustion engines. (Courtesy Amador County Archives.)

The Central Eureka Mine is pictured c. 1940 from Sutter Hill. The headframe and engine house of the mine can be seen on the hill, while the mill is below it. The flume dumping tailings at the impoundment is to the left. This view provides a striking contrast to the claustrophobic work conditions inside the mine. (Courtesy Amador County Archives.)

An infrequent snowstorm dusted the hills south of Sutter Creek. Highlighted at the top is the flume that carried tailings from the mill of the Central Eureka Mine to the impoundment on the Allen Ranch. Serious problems had developed with mines contaminating water supplies and choking rivers with sediments. The final straw came with a severe storm in January 1911, in which 20 inches of rain fell in the vicinity, again sending toxic wastes into local creeks and farmlands. After negotiating with farmers, the mines were ordered to impound their waste by 1915 or shut down. The results were impoundments like this one, designed to keep the tailings from ending up in Sutter Creek. (Courtesy Amador County Archives.)

The Central Eureka Tailings Plant, which reprocessed tailings from the mine's impoundment dam, operated between 1932 and 1938. An extremely toxic process, it resulted in a barren landscape. The plant processed 600 tons a day, or 880,000 tons in its six years of operation, at a cost of $1.50 to $3 a ton. (Courtesy Amador county Archives.)

This interior view of Central Eureka Cyanide Plant dates to 1936 or 1937. The popular method of amalgamating gold with mercury only worked on the free particles of gold. Cyanide leaching was developed to chemically separate the gold from other binding elements. The concrete vat on the right held the toxic solution. The buckets of "zinc dust" on the right were probably used in the process as well. (Courtesy Amador County Archives.)

The changing room of the Central Eureka is festooned with miners' clothing draped over hanging racks. The men would arrive at work in street clothes and change into work clothes in this room. After a shift, they could shower and change back into clean clothes before returning home. Though the wives of the miners probably appreciated the men not coming home dirty, the mine owners had their own underlying reason for such facilities. It prevented, or at least hampered, the miners from stealing or "high-grading" gold-rich ore in their pockets. (Courtesy Amador County Archives.)

The Central Eureka Mine was the last operating gold mine in Sutter Creek. Below, Jim Wooten is pictured at the age of 75, the last surviving member of the three-man crew (including Primo Ferdani and the mine foreman) who closed up the main shaft of the Central Eureka during its last days of operation. When it finally shut its doors in 1958, it brought to a close the hardrock era in Sutter Creek. (Courtesy Amador County Archives and authors' collection.)

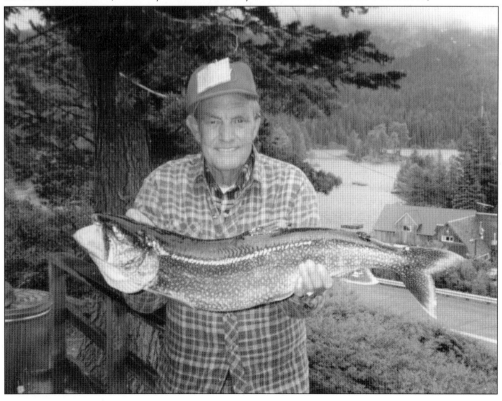

Two

MAIN STREET

The heart of any small town can often be found along its Main Street. Here the populace of the town and surrounding areas come for meals, for provisions, for services, and to socialize. In Sutter Creek, Main Street started as a wide dirt path, dusty in the summer and muddy in the winter, with the main core of businesses running from Church Street north to Hanford Street. It was lined with dry-goods stores, hotels, restaurants, barbers, blacksmiths, livery stables, and saloons. As in every mining boomtown, its existence was tenuous and capital investment limited. When fortunes changed, so did the owners of these businesses, and tracking the history of occupation along the Main Street is a challenge.

In Sutter Creek's earliest days, tents, log cabins, and simple wood structures provided accommodations for residences and commercial businesses, often both in the same structure. When it quickly became clear that the surrounding gold deposits were not going to play out any time soon, further capitol was invested and the tents and cabins gave way to whitewashed, wood-framed buildings. Their faux facades announced everything from baked goods and pickled meat products to store-made suits and sunbonnets to a drink and a roll of the dice. Soon well-established businesses were in place and their merchants respected members of the town. Breweries, foundries, flour mills, and the like began to take hold as Sutter Creek transformed from a mining camp to an established community with a diversified economy. Not even a series of devastating fires, which destroyed much of the Main Street business district during the 1860s, 1870s, and 1880s, could slow the progress of the town. When a building burned to the ground, someone was there to instantly rebuild and another someone was lined up and ready to be their customer again.

The surrounding hardrock mines made Sutter Creek one of the richest communities in the Mother Lode. Those individuals who did not make their money mining for gold stood to do quite well supplying those who had the gold. The affluence of these earlier entrepreneurs can be seen in the beautiful homes along Main Street, as well as the neighborhoods adjacent to the business district. Houses along Spanish Street are some of the earliest in the community and reflect the history of some of the most prominent citizens. Homes on other streets, such as Nickerson, Badger, Broad, Randolph, and others, historically reflect the homes of Sutter Creek's merchants and working families. More than one "payday" home was built room by room, by families whose homes expanded with each paycheck.

In the early days of the 20th century, the automobile came into prominence, bringing another transformation to Main Street. Blacksmiths, carriage shops, and livery stables gave way to garages, auto dealerships, and gas stations. In the 1920s, the dusty path of Main Street was paved, and today it provides meals, accommodations, and a glimpse back through time to tourists who come to experience California's colorful gold rush past.

SUTTER, CALAVERAS COUNTY CALIFORNIA.

This engraving, from an 1854 edition of *Golden Era Illustrated*, presents the earliest known sketch of Sutter Creek. It is an idyllic scene and, along with laundry drying in the afternoon sun, depicts some of the town's most prominent businesses. The American Hotel on the left later became the American Exchange Hotel, though on a different site. The Adams and Company stage office worked from the hotel. The Union Hotel is across the street, situated on the creek. Towards the back, on Little Humbug Hill, sits Hanford and Downs's store. This image was essentially an advertisement for these early Sutter Creek businesses. (Courtesy Amador County Archives.)

The American House, at which the stage is stopped, is seen in one of the earliest photographic images of Sutter Creek, taken by 1853. The man on the far left in the white shirt and the straw hat may be Dwight Crandall (then age 24 or 25), while his brother, Welch Crandall, was identified as fourth from the right wearing the light-colored duster. The hill that rises north of the hotel along the main street is called Little Humbug Hill and appears to be roughly carved to accommodate the wood-frame buildings climbing up its side. (Courtesy Amador County Archives.)

A six-mule team pulling this freight wagon in front of the Hubble Building seems reason enough for celebration in this c. 1870 view of Main Street. Teams and wagons like this were a common sight on Sutter Creek's streets into the first quarter of the 20th century. (Courtesy Amador County Archives.)

Captured in this image is the bridge over Sutter Creek constructed in 1868 by Samuel Knight, prior to the establishment of the Knight Foundry. While the creek is a pretty place to picnic today, during the 19th and early 20th centuries, it functioned as the town's sewer system. A quarter mile up the creek was a structure called a flushing dam. About once a week, when enough water

had been collected, the dam would be opened and the released water would flush away sewage and debris—at least that was the theory. The bridge has been modernized several times over the years. This photograph was taken in 1887 and identifies Fagan's Livery Stable in the background. (Courtesy Amador County Archives.)

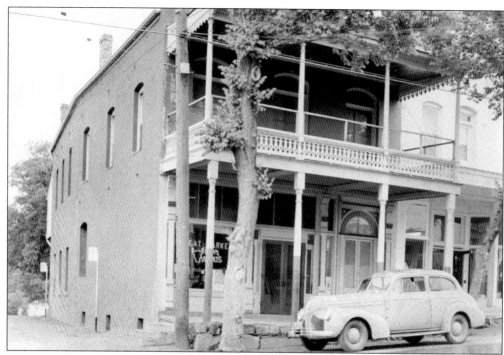

For many years, the Werner (or Swift) Building was known as the Werner Butcher Shop after Fred Werner. George Waechter may have actually operated the shop as the butcher, with Werner raising the stock and supplying the meat. In this early 1940s photograph, neon signs are still advertising meats. Werner's original wood-frame building burned in 1888, and he rebuilt with this two-story brick structure. Below is a c. 1918 view inside of the butcher shop. The men, from left to right, are unidentified, "Cohn," Sam Milasich, and Clarence Feretti. Today no smoked hams or sides of beef are to be had at the Werner Building, which has operated as a gift shop and bookstore for many years. (Courtesy Ed and Margaret Swift.)

And what better to wash down a good steak or piece of mutton than a cool beer? In this 1880 photograph, this establishment was called Randolph's Saloon, operated by I. N. Randolph (pictured here). In 1896, it became Boro's Saloon. Randolph suffered $5,000 in losses for the 1865 fire that burned most of Sutter Creek's business district. (Courtesy Amador County Archives.)

Forty years later, Randolph's and Boro's saloons, at the corner of Main and Randolph Streets, had become Pope's Saloon. This interior image of John Pope's bar, complete with cuspidor, dates to the 1920s. John "Dad" Pope is dressed in the dark suit; the sign over his shoulder reads "No minors allowed, miners welcome." Well over a century later, one can still buy a cold beer at this location after a long, hot ride; it now operates as the Sutter Creek Palace. (Courtesy Carolyn Fregulia.)

This image of a Sutter Creek saloon dates between 1890 and 1910. At one point, it became Rafetta Shoemakers and much later Sparks Bookstore. (Courtesy Carolyn Fregulia.)

Hanford Street, which begins where Main Street curves west, marked the end of the main center of the business district. Boardinghouses, businesses themselves, were located along Hanford, as was the Sutter Creek Brewery. Pictured here in 1891, the brewery was owned and operated by John Raddatz, second from the left. Though many of the buildings of the brewery are long since gone, one stone-and-corrugated iron building still stands. (Courtesy Amador County Archives.)

The American Exchange, established as early as 1851 as the American House, sits at the base of Little Humbug Hill. M. D. Nixon was the proprietor of the American Exchange Hotel and Tavern Bar from 1894 until 1932. Incidentally, receipts show he purchased his beer from the El Dorado Brewery, a distributor out of Stockton. (Courtesy Amador County Archives.)

When someone stepped off the stagecoach and into the American Exchange Hotel for a night's stay, this is the view that greeted him in 1902. M. D. Nixon himself (right) stands behind the cash register, ready to take a customer's money. (Courtesy Amador County Archives.)

Two men dressed in what was very fashionable at the time, especially the individual on the left in a black-and-white checked suit, pose in front of the American Exchange, c. 1890. (Courtesy Amador County Archives.)

Not all of Main Street was given over to business. A number of residences were built along its dirt roads as well. This c. 1860 photograph shows the home of William Wildman and family. Conveniently enough, Wildman's home was also a general store, and when it burned to the ground in 1862 for the second time, he relocated to Main Street near Nickerson. Wildman's early home was located in the same spot as Hanford and Downs's store in the 1854 engraving that begins this chapter and may be the same building. (Courtesy Amador County Archives.)

This snapshot from the 1930s offers a broader view of some of the early residences still located within Sutter Creek's main business district. The Keyes home (left), built in 1895 by John Keyes, is now the Sutter Creek Inn. Standing next door is the Brinn home, today's Foxes Bed-and-Breakfast. In 1865, Morris Brinn purchased the house, which was built by John Davis in the 1850s. The tall building on the end, at one point a private residence, was commercial by this time. (Courtesy Amador County Archives.)

Given the generic title of "Lover's Lane," this postcard actually depicts Spanish Street, one of earliest county roads and city streets. It fronts the creek, west of the business district. The name derives from the area's history as "Spanish Town," where Hispanic miners, generally from Mexico and South America, lived and mined along the banks of Sutter Creek in the early 1850s. More images of the homes along Spanish Street can be seen in chapter four. (Courtesy Ed and Margaret Swift.)

These images, found in the basement of the store, show exterior and interior views of Carlos Soracco's general store from the 1890s. Here the general public could buy items such as tomato catsup or a good bow saw. (Courtesy Ed and Margaret Swift.)

Main Street, Sutter Creek, Cal.

This *c.* 1911 postcard provides one of the best views of the Pinotti Bakery (left) along Main Street. It was established by Thomas Frederickson, who sold it to Pinotti in the 1890s. According to Ed Swift, lifetime Sutter Creek resident, they made the best potato donuts imaginable. Swift also recalled that flour was delivered to the first floor, below street level, through metal doors that opened in the sidewalk. The doors are no longer there. (Courtesy Ed and Margaret Swift.)

This postcard provides a view of the brick Masonic and Odd Fellows Hall, which was erected in 1865 in the wake of that year's devastating conflagration. Next door is the Morris and Siebe Drug Store, which replaced the Dennis Drug Company after 1900. This very quiet view of Main Street was taken during World War I. (Courtesy Amador County Archives.)

Inside the Morris and Siebe store, Rose Tam Siebe takes a moment to smile for the camera, while she operates the switchboard for the Sutter Creek Telephone Company. The Morris and Siebe Drug Store published many souvenir postcards of Sutter Creek after 1905, and many of these have survived as some of the better images of the town's Main Street. (Courtesy Carolyn Fregulia.)

Robert Pope's Emporium, pictured above, sold a variety of items, as noted in a billhead from 1892: "Candies, nuts, books and notions. Also fine domestic and imported cigars and tobacco, firearms, etc." Tobacco was actually grown and dried as a crop for the local market within the Sutter Creek vicinity. (Courtesy Amador County Archives.)

Pictured here is the Brinn Store, located on the north corner of Main and Eureka Streets, which was open for business after 1860. The brick structure was built in 1873. It was gutted and its walls collapsed in the 1888 conflagration; the existing structure replaced it. Brinn sold the store near the dawn of the 20th century, and it later became Malatesta's, continuing to operate as a mercantile and sporting goods store. For many years now, it has served as a restaurant, providing good food to locals and visitors alike. (Courtesy Amador County Archives.)

A massive wreathed arch spans the town's Main Street, which is also decked out in American flags for a celebration, possibly the Fourth of July. The porch of Malatesta's General Store can be seen, the first building on the right, dressed up with crisscrossed bunting that appears to be the tricolored Italian flag. Based on the automobiles, this postcard dates to 1925. (Courtesy Amador County Archives.)

Just up Eureka Street from Malatesta's was Cap's Garage. In this early 1930s photograph, Joe Capetanich (standing) and Shirley Clemens (kneeling) are seen next to the volunteer fire department's Dodge truck. The town suffered through many fires, and by 1870, the Hook, Ladder, and Bucket Company, made of volunteer citizens, had formed and built a fire hall on Spanish Street. Today the community still relies on its volunteer firemen and women. (Courtesy Ed and Mimi Arata.)

Fabric, ribbons, and ready-to-wear suits and bonnets are on display in the front window of Futter's Cash Store, *c.* 1900. Factory-manufactured clothing became available in the 1860s, and store owners were quick to capitalize on these expensive products. Rebecca Futter is seen here, second from the left. Futter's store was located in the Hubble Building. (Courtesy Amador County Archives.)

Another Sutter Creek mercantile during the 1930s, its walls papered in elaborate designs, remains unidentified. (Courtesy Carolyn Fregulia.)

Above, Lorenzo Cuneo stands in front of his plumbing shop on the east side of Main Street, between Church and Eureka Streets. Below is an interior view of his well-stocked store. When Cuneo bought out the previous owner in 1901, only three or four homes in Sutter Creek had indoor plumbing. He is credited with plumbing most of Sutter Creek. (Courtesy Carolyn Fregulia.)

The Donnelly and Howard Foundry was a large complex running along the creek on the corners of Main and Foundry (now Badger) Streets. By 1895, its core buildings along Main Street had been replaced by the Electric Light Company's water-powered plant, and its smaller buildings were vacant. Within the next three years, Amador County Steam Laundry built over the remaining foundry buildings, leaving no architectural traces of the operation. By the 1930s, the Sutter Creek Garage had replaced the local electric company with a new garage, but the steam laundry was still in business. Pictured here along with his foundry workers is Daniel Donnelly (far left) sometime prior to his death in 1890. (Courtesy Ed and Mimi Arata.)

This detailed Sanborn Fire Insurance map shows the Donnelly and Howard Foundry in 1890. While the foundry was listed with "7 hands; no night watchman" on the map, the Knight Foundry was listed as having "25 employees, 7 a.m. to 6 p.m.; no night watchman." Also, Knight had electric and candle lighting, while Donnelly only had candle. Perhaps these distinctions forecasted one foundry's failure and the other's survival. This map also provides a good view of Fagan's Livery and Feed complex, as well as the buildings in George Allen's lumberyard, up Church Street. A blacksmith shop on Church and Main Streets is also depicted. From the 1870s into the 1950s, the Sanborn Fire Insurance Agency created detailed maps of the communities to which they provided fire insurance. Sutter Creek's maps, which span 1890 to 1930, have proved immeasurably valuable to historians and historical archaeologists, providing some of the most detailed information available on long gone buildings. (Courtesy Ed and Mimi Arata.)

Above is a postcard view of the Amador County Steam Laundry. Established in 1896, it replaced the last remnants of the Donnelly and Howard Foundry, which had been demolished earlier in that decade. In the *c.* 1896 photograph below, women are hard at work on the second floor of the Amador County Steam Laundry. (Courtesy Ed and Margaret Swift.)

This lithograph of Fagan's Stable was created for the 1881 Amador County history, published by Thompson and West. They state that Fagan had "the satisfaction of knowing that his is the only first-class establishment of the kind in the town, in fact, no better can be found in many large cities." Fagan built his livery stable in the mid-1860s, later renaming the business Sutter Creek Livery and Feed. The main floor contained a harness shop, carriage shed, wash shed, and general feed store, as well as board for horses with a corral and barley mill out back. (Courtesy Amador County Archives.)

Dating to the early 20th century, the photograph shows a cattle drive down Main Street and up Church Street. On the south corner of Church Street, the dark, wood-frame building with a stepped false front housed another blacksmith and carriage maker's shop, apparent by the iron carriage wheels scattered out front. Across Church Street stands the Methodist Episcopal Church, with its new vestry. (Courtesy Amador County Archives.)

A blacksmith was conveniently located next door to Fagan's livery, just to the left of the church. At some point after 1912, the blacksmith building disappears from the Sanborn Fire Insurance maps. It is interesting to see a blacksmith shop and a garage in the same image. This image dates between 1910 and 1928. Note the tiny, white, false-fronted structure that stands alone on the hill overlooking Main Street. The Slavonic Illyric Society Hall, built in the late 1870s, can be seen in many overviews of the town. (Courtesy Amador County Archives.)

D. A. Fraser, blacksmith and carriage maker, was in business next to Fagan's Livery. This *c.* 1897 receipt was from one D. P. Colwell, "Practical Horseshoer," to R. C. Downs for $4 worth of shoes. Where Colwell practiced his farrier skills may never be known, but prior to Ford making the automobile affordable, there were multiple smiths in Sutter Creek. In fact, one worked at the corner of Church and Main Streets; perhaps Dr. Colwell worked there. (Courtesy Ed and Margaret Swift and Amador County Archives.)

This image shows the demolition of Fagan's Livery—one story claims that the building was burned—but this image clearly shows the livery building being dismantled. According to Ed Swift, lifelong Sutter Creek resident, what wood could be recycled was used in building the new auditorium. Perhaps the rest of the structure was burned. (Courtesy Ed and Margaret Swift.)

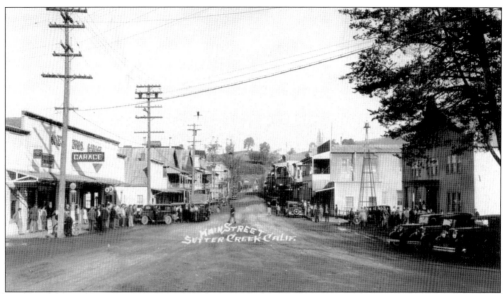

Fagan's Livery had survived the devastating fire of 1888, only to be purposefully dismantled and perhaps burned to make way for the city's new auditorium. Built in 1928, the Sutter Creek Auditorium still provides space for city offices and public functions. The auditorium can be seen in the foreground on the right, while the Oneto Brothers Garage is on the left. Still unpaved but now "oiled," Main Street leads towards the rest of the business district in this mid-1930s view. (Courtesy of the Amador County Archives.)

The Oneto brothers opened their garage in the 1920s. Previously it had been home to the Amador Electric Light and Power Company, originally named the Amador Electric Railway and Light Company. The founders' intention had been to build an electric railway line, primarily for passenger service, between Drytown and Jackson. It was reorganized after 1910 as the Amador Electric Light and Power Company and shortly thereafter purchased by Pacific Gas and Electric Company. All these businesses were built on top of the original location of the Sutter Creek Foundry, later the Donnelly and Howard Foundry. (Courtesy Amador County Archives.)

Providing a striking contrast between old and new are the Richards Building (left) and the Ratto Theater. In this 1930s view, the Richards Building represents a good example of Mother Lode architecture with its wood-frame, balcony-lined, false-fronted facade. Built after the 1888 conflagration, it housed C. E. Richard's general store for many years. The 1919 Ratto Theater, the Sutter Theater in this photograph, is quite modern in comparison. Today it provides the town with a wide range of events as the Sutter Creek Theater. (Courtesy Amador County Archives.)

These two postcards also provide a good example of the "modernization" of one building. An icon in the early imagery of the town, the above image of the American Exchange Hotel catches the establishment around the beginning of the 20th century. Stagecoaches, leaving promptly at 7:30 a.m., made the American Exchange Hotel a regular stop. In the early 1930s, the building was brought into the 20th century by removing the balcony and adding stucco siding and a neon sign. (Courtesy Amador County Archives.)

A c. 1902 photograph of the interior of the American Exchange Hotel Bar shows the bartender ready to pour a cold beer to weary stage travelers. Remodeled in 1932 by Jimmy Bellotti, it became the Sutter Club. The lower postcard is an advertisement for the newly remodeled club, still inviting to those traveling long distances but now by car. The curve of the bar is all that remains recognizable. (Courtesy Amador County Archives.)

SUTTER CLUB LOUNGE, SUTTER CREEK, CALIF

This contemporary image of a newly "rebalconied" American Exchange Hotel shows the building looking much as it did at the beginning of the 20th century. The establishment has even regained one of its earlier names, the American Exchange Hotel, in the last few years. (Courtesy authors' collection.)

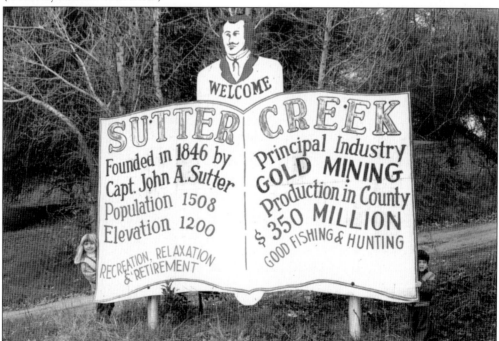

Sutter Creek's sign has greeted visitors coming north along Highway 49 onto Main Street since Maurice Boitano made the original design. It has been lovingly repainted with the population numbers slowly increasing since it was put in place in the late 1930s. History hasn't caught up to the sign over time though. John Sutter did not found Sutter Creek in 1846, or any other year for that matter, but he did provide the city with its namesake. (Courtesy Ed and Margaret Swift.)

Three

KNIGHT FOUNDRY

As the hardrock gold mines in and around Sutter Creek grew bigger and deeper, larger machinery was needed to work them. Mine operators had two options: import the machinery from elsewhere, or try to make it themselves. Shipping the heavy machinery in was expensive, and manufacturing capabilities at the mines were limited. To fill the need for locally produced mining equipment, several foundries were established. In the 1850s, Coffin and Hitchen's Foundry, Tibbits' Sutter Creek Foundry, and others established Sutter Creek as the foundry town of Amador County. In 1873, Campbell, Hall, and Company built a foundry on what is now Eureka Street. Eventually Samuel Knight, a former ship's carpenter, bought into the operation, and soon the foundry was known as the Knight Foundry.

With startling ingenuity, Knight utilized the high-pressure water system developed for placer mining to power his foundry. Waterwheels of his own design powered the furnaces and associated shops. Knight Foundry was a self-contained industrial venture that included not only a foundry but also a pattern shop, machine shop, and blacksmith shop. Knight's establishment was capable of designing and producing complicated machinery from start to finish. Their first customers were the mines for whom they produced hoist works and other machinery. The foundry gradually diversified, producing a wide variety of materials from street lamps to components for the railroad. One of the most famous products was the Knight waterwheel, which was used to power hoist works, stamp mills, sawmills, electrical generators, and a host of other industrial facilities. The first electrical lights in Sutter Creek were at Knight Foundry, powered by a generator turned by one of Knight's waterwheels. Though ultimately surpassed by other technologies, the Knight Wheel was an important step forward in the harnessing of water power.

Even after the mines closed down after World War II, Knight Foundry continued to pour iron for many years. They produced niche items that other facilities refused to tackle. Until the end, the foundry relied on the water-power system Samuel Knight had developed in the 1870s. After years of slowly declining, the foundry finally closed its doors in 1984, ending the last vestiges of Sutter Creek's once industrial-based economy. Due to the foresight of interested parties, the foundry was not scrapped like most retired industrial facilities. Behind locked doors sit all of the machines as they were left, and with the simple twist of a water valve, one of Knight's trusty waterwheels brings the machines to life. Though much of the technology is well over 100 years old, the foundry is still capable of producing quality products. Efforts of dedicated individuals continue in the hope of reopening the foundry as a living history facility, where apprentices can learn nearly lost arts and the public can once again watch as one of the most well-preserved 19th-century industrial complexes comes back to life. Hopefully one day, in the not too distant future, the distinct hum of the machine shop and the roar of the furnace will be heard again in Sutter Creek.

Knight & Co's Shops at Sutter Creek.

This late-19th-century lithograph portrays the Knight Foundry as seen from Eureka Street. The tops of the two cupolas can be seen belching fire from the roof. The other smaller stacks were for a forge and probably a core oven. The foundry was divided into two sections. The back half, where the stacks are protruding, housed the cupolas where the iron was melted and poured. The front portion contained the machine and pattern shops. The small building in the background was the pipe fitting shop. (Courtesy Amador County Archives.)

Looking east up Eureka Street is a view of Knight Foundry. Note the two large cranes in the foreground and background. These were used for moving materials and finished products from one building to the next and for loading and unloading wagons. A whole series of these cranes was positioned around the foundry, allowing movement of large objects from one crane to the next. Note the pipe rack to the right. (Courtesy Amador County Archives.)

This view shows the eastern portion of the foundry where the iron was poured. In the background are the foundry's two cupolas. The elevated platform attached to the cupolas is the charging deck. From here, men shoveled in the "charge," a load of coke and iron, through an opening partway up the cupola. Air was forced in from the bottom of the cupola to help the coke burn, melting the iron. The smaller cupola on the right could also be used for pouring brass or bronze castings. Flasks of various sizes are scattered about the shop. The men in the foreground are ramming up a form for a large casting. The pattern reads "The Knight Co. Sutter Creek Cal. 1922." Exceptionally large castings were molded into the floor of the building. The large crane in the center was able to swing a full 360 degrees about the room, reaching from the cupolas to the front door. (Courtesy Carolyn Fregulia.)

The foundry men are pouring the iron from the crucible into a large form or flask, c. 1950. Other flasks are lined up in the background ready for pouring. Flame is erupting from sprues and risers, holes in the form used to pour the iron in and allow excess gas to escape. (Courtesy Amador County Archives.)

The Knight Foundry is seen *c.* 1890 with one of Knight's famous waterwheels propped against the tree on the left. Samuel Knight is standing in the foreground, prominent with his white hat

CHINE SHOP OF
. SUTTER CREEK, CAL.

and walking stick. The tree-lined street is in stark contrast to the barren mining landscape that surrounded the town. (Courtesy Amador County Archives.)

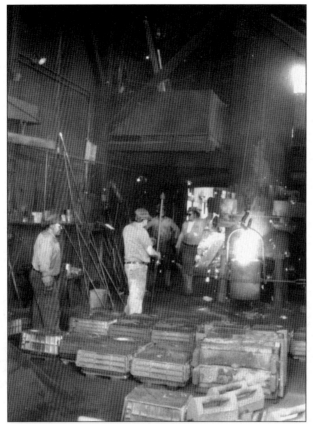

This iron pouring occurred in 1973. Molten iron is being drained from one of the cupolas into a crucible, which in turn was poured into the flasks scattered about in the foreground. Light can be seen streaming in from the opening for the charging deck above. In the lower view, the crucible is supported by a large crane while the foundry men transfer the iron to the flasks, which hold the patterns molded in sand. The objects sitting on top of the flasks are weights used to keep the flask tops from being forced up by the molten iron during the pour. Carl Borgh (below) prepares to pour a new mold. The Borgh family owned the foundry for several years and kept the foundry pouring and apprentices learning through their years of ownership. (Courtesy Amador County Archives.)

This image of the Knight Foundry machine shop was probably taken around the turn of the century. To the left in the foreground is a mill used to plane castings flat. In the background are a series of lathes used for machining shafts and other circular objects. One of the large cranes, seen to the right of center, was used to move project components from one machine to the next. The overheat shafts and belts run across the ceiling. One of Knight's waterwheels drove all of this machinery. Note the single light bulb on the ceiling; Knight Foundry was the first establishment in Sutter Creek to have electric lighting. The foundry generated its own electricity with one of Knight's waterwheels connected to a generator. (Courtesy Amador County Archives.)

Workers inside the blacksmith shop are apparently preparing to shoe a horse, which poses patiently for the photograph. The shop was probably in the main foundry building initially but was later moved to a small building on the south side of Eureka Street (Courtesy Amador County Archives.)

The layout of the Knight Foundry buildings can be clearly seen is this 1930 Sanborn Fire Insurance map. Here the blacksmith shop has already been relocated to the south side of Eureka Street. Many of the houses surrounding the foundry, depicted on the map with a "D" for dwelling, were homes Knight provided for his workers. (Courtesy Ed and Mimi Arata.)

This photograph of the Knight Foundry employees, posing in front of the foundry with their children, dates to 1886. A miniature Knight Wheel rests in one man's lap, while a full size wheel with replaceable buckets leans against the building. The man to the right holds a rod used to drive the clay plug out of the cupola, allowing the iron to flow out during a pour. (Courtesy Amador County Archives.)

Elbridge Post was born in Sutter Creek in 1861. While his parents, John and Matilda, had a vineyard on their Sutter Creek ranch, Elbridge was not drawn to farming. He became an apprentice at the Knight Foundry, eventually becoming a master mechanic. An apprenticeship at the Knight Foundry was a virtual guarantee of work anywhere one desired to go. Post eventually put the skills he had gained at the foundry to work at the Kennedy Mine in Jackson as their master mechanic. (Courtesy Ed and Mimi Arata.)

Knight and his foundry were best known for their waterwheels. Knight made vast improvements over the old wooden waterwheels in use when he first arrived in Sutter Creek. He finally settled on this all metal wheel with a cup shape and nozzle of his own design. Knight's wheels were used to power hydroelectric plants, mine hoists, stamp mills, and endless other applications. Each page of the 1896 company catalog is captioned with the claim "90 Waterwheels, Running over 2000 Stamps. 300 Knight's Wheels, Giving out 2500 Horsepower." (Courtesy Amador County Archives.)

Waterwheels similar to this one still power the machine shop and cupola air injectors at Knight Foundry. Knight was in a constant battle with several other inventors to come up with the best design for a waterwheel. To settle things once and for all, a contest was arranged in Grass Valley to which Knight and several of his competitors brought their best design. A competing design, the Pelton Wheel, proved the most efficient and won the contest. After that, the demand for Knight's wheel slowly declined. (Courtesy Amador County Archives.)

In this image, several of the foundry workers pose in front of one of their more impressive products. This massive device was a pump for a dredge. This and similar pumps made by Knight Foundry were used from San Francisco all the way to Portland, Oregon. (Courtesy Amador County Archives.)

Another one of Samuel Knight's inventions was this self-propelled rock crusher, used to pave roads. Knight himself is shown driving the contraption in this etching. (Courtesy Amador County Archives.)

Samuel Knight passed away from pneumonia on January 13, 1913, but his foundry continued on for more than 60 years. It still stands today on Eureka Street as a testament to his ingenuity. Attempts to restore the foundry to full operation as a living history industrial park have been ongoing. (Courtesy Amador County Archives.)

Four

PIONEER FAMILIES

Like most gold rush towns, Sutter Creek was a strikingly cosmopolitan community. The Americans who flooded in from the eastern United States were joined by men and women from Europe, Asia, and Central and South America. For all, the West was unfamiliar territory. Californios, already living and ranching in California, were among the first to arrive. One such citizen who mined along the local creeks in the early days of the gold rush, Jose Maria Amador, lent his name to the county. In Sutter Creek, names like Spanish Street are a quiet reference to this history.

Men from Central and South America were some of the first experienced miners in the area, having labored in the gold and silver mines of their home countries. They brought with them important technology for California's fledgling mining industry, including the arrastra and Chilean mill. They were soon outnumbered by the flood of people from the eastern United States. American prospectors readily adapted Mexican and South American technology for their own use while simultaneously legislating against the access of foreign miners to the gold fields. Europeans of all nationalities came as well. Cornish and Welsh are well known for their role in the mining industry of the American West.

New Englanders such as Downs, McIntire, Hanford, and Keyes settled in the first decades of Sutter Creek's establishment. One of the most notable early pioneers was Edward B. McIntire, who came to Sutter Creek in 1850. The family and business ties that would come to exist between the McIntire, Keyes, Voorheis, and Clark families would help shape the community. George Allen arrived in the county by 1860, quickly establishing himself as a cattle and horseman, lumber merchant, and landowner. Members of the Allen family continue to live on and ranch George Allen's original lands around Sutter Creek. Others, like early industrialist Samuel Knight, left the town with a rich legacy that persists today.

Sutter Creek was also home to a sizable Chinese population, which eventually had to contend with severe anti-Chinese exclusion legislation. When the easily accessible placer deposits dried up, the Chinese, like everyone else, looked for gainful employment elsewhere and found it as cooks, merchants, wood cutters, and laundry operators. A Chinese laundry was located in a tiny building on Spanish Street until at least 1912.

One of the largest populations to emigrate to Amador County was from northern Italy, in particular the Liguria region. Poverty and hope motivated them to leave their homeland, and community and a familiar climate drew them to the foothills. Some family names are still familiar in the community today: Marre, Pinotti, Boitano, Brusatori, Lagomarsino, Garibaldi, and Botto, to name a few; others have been lost to history. They came as miners, laborers, stonemasons, farmers with their "truck gardens," and vintners. Today nearly two million Californians claim Italian descent and were historically one of the state's largest immigrant groups.

The opportunities to succeed and fail in the early days of California's statehood and Sutter Creek's establishment were immense. Many hopeful pioneering families, with their own rich and colorful histories, arrived in Sutter Creek in the early decades of California's statehood. Some left little trace of their sojourn, moving on to the next town, while the descendants of other families, not all of whom it is possible to mention within the confines of this chapter, remain in the community today.

GEN. JOHN A. SUTTER

This engraving of Gen. John A. Sutter from *Gold Mines of California* (no date) is the best place to begin looking at those who influenced Sutter Creek's early development. Sutter, living on his land grant in New Helvetia (Sacramento), hired men to search nearby lands for good lumber stands. They found those stands as early as 1844. The name for the camp and sawmill was Pine Woods and is thought to be located a few miles east of today's town site. Sutter himself came with hundreds of other prospectors to search for gold in the creek near Pine Woods in 1848, and by the time he left, the anonymous creek and growing mining camp was known by his name. (Courtesy Amador County Archives.)

This portrait of Alvinza Hayward, perhaps California's first mining millionaire, was taken during the mid-1860s as a member of the Sutter Creek Masonic Lodge. He arrived in the camp as the quartz era began, where he became affiliated with the Badger Mine. By the late 1850s, he had consolidated the Badger, Wolverine, and Eureka claims into Hayward's Mine. As one article described the mine, it was "better known by the name of the man whose energy, with a good share of luck, developed it into, probably, the best-paying gold mine in the world." Hayward and his partners eventually owned a connected infrastructure of ditches, property, mineral rights, and mines throughout Amador County, but it was Hayward's Mine that made him a rich man. (Courtesy Amador County Archives.)

This daguerreotype was taken in 1859 around the time 33-year-old John Keyes married 18-year-old Clara McIntire, daughter of Edward and Mary McIntire, town pioneers. Keyes arrived from New York in the early 1850s, establishing himself as a merchant along Sutter Creek's Main Street. One of the brick stores he built in the late 1850s still stands, now the one-story annex to the American Exchange Hotel. John died in 1875 at the age of 48, leaving Clara widowed. (Courtesy Amador County Archives.)

One of the many 1850s wood-frame homes still standing in Sutter Creek is the old McIntire home on Spanish Street. The photograph, taken in the 1880s, shows Edward Bucknam McIntire [McIntyre], his wife, Mary, and their young granddaughter, Gertrude Voorheis. McIntire was one of the first prospectors to establish roots in Sutter Creek. Leaving his wife and children behind in New Hampshire, McIntire sailed for California in 1849. By 1851, he had made his way to Sutter Creek and was a stockholder in one of the area's earliest quartz mines. Mary, along with their youngest son, Ephraim, arrived in 1851; the two older children, John and Clara, came west in 1856. Like many early pioneers, McIntire took his civic duties very seriously and was elected in 1856 to both superintendent of common schools and justice of the peace for Township 4, of which Sutter Creek was the central locality. (Courtesy Amador County Archives.)

One of the most recognizable homes fronting Main Street is the Keyes Home. Better known today as the Sutter Creek Inn, it is reputed to be the first bed and breakfast in the West. Designed in the Greek Revival fashion, the main body of the home was built by John Keyes for his new bride, Clara McIntire, in 1859. After John died in 1875, Clara remarried Edward Voorheis in 1880. Nine years her junior, Voorheis had come to town to join relatives in operating a mining reduction works. In this mid-1880s photograph, Clara and Edward's daughter, Gertrude, can be seen standing on the front porch with her governess. Edward and Clara remodeled the home in 1882. (Courtesy Amador County Archives.)

Edward Converse Voorheis came to Sutter Creek in 1877. With profits he earned from operating mining reduction works in Drytown and Sutter Creek, Voorheis invested in several major mines in the county. In 1880, he married the widowed Clara McIntire Keyes, and together they began a family. As a Republican, Voorheis was elected to the state senate. He represented Alpine, Amador, Calaveras, and Mono Counties from 1891 to 1897 and held the powerful position of finance chairman. A lifelong advocate for the mining industry and one of Sutter Creek's most influential citizens, he died in 1925. Clara passed away in 1915, a well-respected member of the community; she was buried next to her son, Earl Garland Voorheis, who died in infancy in 1882. Below right is a photograph of E. C. and Clara's daughter, Gertrude Voorheis Clark, with her young children Baylies and Mary Elizabeth, c. 1910. (Courtesy Amador County Archives.)

Gertrude Voorheis, daughter of Edward and Clara, married Baylies Coleman Clark, a native of New York. After 1900, Clark mined in Mexico, Auburn, and Sacramento, among other places, eventually returning with Gertrude to settle in the family home. He was elected mayor of Sutter Creek for a time. This photograph is from a governor's luncheon hosted at the Clark home (Keyes House) for California governor Culbert L. Olson in 1940. Gertrude can be seen standing next to the horse and rider on Main Street, waiting for the Gold Rush Parade to begin. (Courtesy Amador County Archives.)

George Allen arrived in San Francisco in 1860 by the Isthmus of Panama and immediately headed out for Sutter Creek. A local history published by Thompson and West stated, "He has been engaged in various kinds of business since arriving at this place, principally teaming, lumbering, and stock-raising . . . having the only lumberyard in Sutter Creek. A good portion of the time he has several teams on the road, hauling lumber from his saw-mill, better known as Tarr's Mill, situated about ten miles above Volcano." The family raised stock including horses, mules, and cattle on a 2,700-acre ranch on the outskirts of Sutter Creek. This lithograph provides a view of the Allen Home and lumberyard. (Courtesy Ed and Mimi Arata.)

GEORGE ALLEN.

George Allen and his wife, Annie E. Bradbury Allen, are depicted in these lithographs published in 1881. He and Annie were married in Amador City in 1870, and by the time his biography was published in a community history in 1881, he and Annie had five children, four of whom lived. Allen was a native of New York where he was a farmer, while Annie came from Maine. (Courtesy Ed and Mimi Arata.)

MRS. GEO ALLEN.

Mildred Allen, granddaughter of George and Annie Allen, attended the grammar school and was also a member of one of the first classes to attend the newly constructed County High School. She is pictured above as a member of the girl's high school basketball team. From left to right are Hilda Rizzi, Lenore Gillick, Helen Mugford, Ethel Jones, Mildred Allen, Eva Milosich, Ella Acampo, and Ann Wood. (Courtesy Ed and Margaret Swift.)

The residence of R. C. Downs, depicted in this 1881 lithograph, remains one of the most beautiful homes to grace Spanish Street. Robert Downs worked at several successful businesses, as both merchant and miner. His greatest success perhaps was as a major stockholder and the superintendent of the Lincoln Mine. He persuaded Leland Stanford to buy the defunct Union Mine, and his foresight made Stanford one of California's richest men. (Courtesy Amador County Archives.)

Peter Fagan, a native of Canada, came to Sutter Creek in 1858. After four years as an engineer at the Eureka Mine, he tried his hand at teaming. He established his livery stable and carriage shop the mid-1860s. He owned a home off Church Street behind his livery stable as well as 140 acres near town. Unlike most individuals who purchased a "spot" for a portrait in the town's history book, Fagan chose to have his three children depicted in this lithograph from 1881. He and his wife, Maggie Duke, eventually had 12 children together. (Courtesy Amador County Archives.)

This photograph, taken around 1900, shows William Harold Trelease operating the hoist works of an unknown Sutter Creek mine. William was born in Penzance, Cornwall County, England, in 1867. He married Anna Maria Bowden in Sutter Creek in 1890; she was also from Penzance. When William died, Anna married John Pope. Anna died in 1950. (Courtesy Carolyn Fregulia.)

This image shows the Trelease family in front of their Sutter Creek home. Of Cornish descent, the Trelease family represents one of many English families from the Cornwall region who had generations of mining in their blood. Although the image is not dated, it likely from around the time of William Trelease's death in 1906. Pictured, from left to right, are Walter and Gertrude and their parents, William and Anna. (Courtesy Carolyn Fregulia.)

This portrait dates between 1908 and 1910. Walter Trelease is standing in the back, and his younger brother, Carl Ross, is sitting in front of him on the far right. There were other Cornish families in Sutter Creek, and the Trelease family is meant to represent their history here, of which little has been written. (Courtesy Carolyn Fregulia.)

In 1881, the *Societa Unione e Beneficenza Italiana* or Italian Benevolent Society was established. Benevolent societies, which different immigrant groups formed, provided mutual aid in times of hardship, such as with burial expenses and widow's funds. They were generally fraternal organizations that strengthened community bonds, and in the case of the Italian Benevolent Society, honored the homeland. Beginning in 1882, their constitution required that the society stage an annual celebration for the Italian Republic on the first Sunday in June. This photograph, from the mid-1890s, shows the speakers' platform from such an event, where speeches could be heard in both English and Italian. Identified on the far right are Divol Spagnoli (holding the cane) and his son, Ernest. The senior Spagnoli was U.S. Consul to Milan, Italy, and a prominent attorney, merchant, and county official during his Amador years. (Courtesy Amador County Archives.)

A car decorated for the Italian Picnic Parade, c. 1915, provides a classic image of a celebration that continues to occur today. This postcard is one of the few historic images that can be definitively linked to the Italian Picnic Parade. Note the Preston Band lined up behind the float. The county's Italian heritage continues to be celebrated along Sutter Creek's Main Street on the first Sunday in June. (Courtesy Amador County Archives.)

In 1871, Emmanuela Curotto was one of three daughters born to Barthalamio (also Bartolomeo) and Maria Giambruno Curotto. Barthalamio, along with four other men, survived the Lincoln Mine disaster of 1873, which cost nine miners their lives. Through Maria Giambruno's sister, Domenica, and the later marriages of the Curotto daughters, the current day Arata, Boitano, Swift, Allen, and Manassero families of Sutter Creek are related. (Courtesy Ed and Mimi Arata.)

Lorenzo Cuneo, born in the French Gardens outside Jackson, is seen standing (right) inside his plumbing workshop on Main Street. Though there were other plumbers before him, his venture into the plumbing business corresponded to a time when the idea of indoor water closets and plumbing was beginning to take hold. Rumor has it that he was single-handedly responsible for bringing plumbing to much of Sutter Creek. (Courtesy Carolyn Fregulia.)

Azalea Cuneo was a lifelong resident and well-known figure in Sutter Creek. Born to Lorenzo and Teresa Molfino Cuneo in 1911, she died in 2005, a lifelong resident of Sutter Creek. She is pictured here (second row from bottom, second from left in a dark dress) as a fifth grader in a 1924 class portrait from Sutter Creek Grammar School. Along with Azalea, the Cuneos had three older boys, Leland, Stanley, and Russell. The descendants of the Cuneo family continue to live and work in Amador County today. (Courtesy Amador County Archives.)

Pictured here are Carlo "Charles" Soracco and his wife, Giovanna "Joanna" Soracco, in the 1860s. Later that decade, Carlo became part-owner of Soracco's General Store and eventually purchased the business outright. This portrait of Charles Soracco dates to the dawn of the 20th century. Married in 1876, Charles and Joanna had five children, who eventually helped to run their parents' store. Images of their greenstone store can be seen in chapter two. (Courtesy Carolyn Fregulia.)

Sebastiano Solari married Maria Bianchetti in 1864.
This family portrait of the Solaris is from the 1870s,
showing Sebastiano and Maria surrounded by
their children Connie, Daniel, Louisa, John,
and Tellie. (Courtesy Carolyn Fregulia.)

Here Sebastiano and Maria Solari and one of their sons work cutting a crop on their garden in
Sutter Creek, c. 1919. The Solaris operated a truck garden from their farm in Sutter Creek. Prior
to 1912, many areas within Sutter Creek had working gardens, and a small handful continue to
operate today. (Courtesy Carolyn Fregulia.)

In another example of teaming, Louis Monteverde, from a Sutter Creek merchant family, is hauling freight from Ione to Sutter Creek. The Monteverde family owned a mercantile in Sutter Creek, located a block off Main Street on Randolph. The building was donated to the city for use as a museum by descendants of the Monteverde family. Visitors there today can see a mercantile much as it would have appeared in the early 20th century. (Courtesy Amador County Archives.)

Family bonds were strong in Italy, and those who had migrated to the United States—even family members separated by many generations—made efforts to maintain correspondence. Letters and postcards were written back and forth between the foothills and the "home country" frequently and helped keep cultural roots and family ties alive. By the 1950s, the pressure to be seen as an American resulted in the loss of Italian as a spoken language for many second and third generation children. These postcards from the late 1920s show scenes of Chiavari and Lavagna, in the Genoa Province, where many of Amador's earliest Italians hailed from. (Courtesy Gary and Paula Wooten.)

Henry Garibaldi is pictured here standing in front of his home during the 1950s. The house, constructed in the 1850s, was once the Eureka Mine foreman's home. He was the son of Pietro (Peter) Garibaldi, who homesteaded on lands west of Sutter Creek. Henry's brother, Clarence, also lived in Sutter Creek; he and his family occupied one of the beautiful homes along Spanish Street. His daughter, DeAnne Garibaldi, is one of the children in the Sutter Creek Grammar School class picture on page 105 (second row from bottom, eighth from the left, in the dark sweater). (Courtesy Gary and Paula Wooten.)

Mary "Dolly" Garibaldi was born Maria Jochamina Octavina Zolezzi in 1907, the daughter of Italian immigrants Juanita and Emilio, from Lavagna, Italy. She came to Amador County from San Francisco to marry Henry Garibaldi in the 1930s. The couple had three children, pictured here in 1945, Peter, Janette, and Paula. Henry and Mary later came to own the remains of the early Badger/Wolverine, Keystone, and Plymouth Consolidated mines. Though a lifelong dream, Henry was never able to reopen the mines. (Courtesy Gary and Paula Wooten.)

The Botto building, whose ruins are pictured here in the 1960s, was once a saloon and boardinghouse. The saloon was located on the road running past the Central Eureka. The Botto Ranch was up the "Creek Road" (Church Street) about a mile out of town. (Courtesy Amador County Archives.)

For many years, the Summit Hotel was run by J. Ghiglieri. It was located just south of the Botto Saloon along the road to the South Eureka Mine. This photograph dates to the early 1900s, and Ghiglieri is most likely one of the men in the upper image, though he is not identified. The hotel is no longer standing. (Courtesy Amador County Archives.)

Two views of the statue *To the Immigrants* are shown from its home in Cicagna, Liguria, Italy. It represents the moving story of the men who left Italy to create a better life in California, leaving families behind until they could save enough for passage to America for their loved ones. Sometimes families were separated for years, sometimes for a lifetime. This statue is meant to remember and honor this struggle. (Photographs by Ed Arata.)

Five

SCHOOLS AND CHURCHES

Even before its incorporation in 1854, Sutter Creek's citizens were becoming more diverse. The town was no longer comprised solely of bachelor miners hardened by the realities of a frontier so distant from "civilized" life. A growing community of women, children, and extended families were arriving daily. These families needed a healthy social life, with an education that fed both the mind and spirit—something perhaps easily misplaced on this western frontier.

Life in Sutter Creek could be very hard, and death was always present; the need for houses of faith and cemeteries to bury the faithful was apparent. Still, formalized preaching did not occur until the late 1850s. The Catholic congregation built the first church, the Immaculate Conception, in 1861 on Spanish Street. Its location in "Spanishtown" was not surprising as the Mexican and South American population was predominately Catholic. The congregation grew with the arriving Italian and Irish immigrants. The Methodist congregation also organized early and built the Methodist-Episcopal church in 1862. Like much of the town, it was razed in the 1865 fire, quickly rebuilt, and still stands on the corner of Main and Church Streets today. The members of the Trinity Episcopal Church established themselves rather late in Sutter Creek's history, organizing in the late 1890s. The church was built on Amelia Street just after the beginning of the 20th century. The city's cemeteries are filled with graves of men, women, and children who settled the town.

A good education was also essential, but as with many towns in the Mother Lode, teachers and books, let alone schoolhouses, were not readily available. The first formal education was likely delivered in someone's parlor or by a man of faith, but soon the citizens of Sutter Creek saw the need to establish a permanent schoolhouse. Built in 1856, it was located on School Street (now Anna), and children from as far away as Plymouth and Latrobe attended. This first school burned to the ground in 1870, in what has passed down through time as a rumor of arson based on differences over teaching African American students. By 1871, funded by a community-supported bond, the grand Sutter Creek Grammar School was built in a new location and served Sutter Creek's children into the 1960s.

In 1910, the Sutter Creek Women's Club was formed with the sole focus of generating support in town for a high school. At that point, the only high school in the county was located in Ione, which made for a difficult journey daily for Sutter Creek's children. In 1911, after a bitter fight with Jackson to host the new school, the decision was made to locate in Sutter Creek. The first students were temporarily instructed in buildings at George Allen's Lumberyard off Church Street. That first year saw 28 students and two teachers. In 1913, the cornerstone of the County High School was laid with much fanfare at the top of Spanish Street. After serving several generations of students from Sutter Creek, as well as northern and eastern Amador County, the original school was razed in 1975, replaced with new buildings that could accommodate a growing student body.

In 1859, Rev. Benjamin Meyers "passed the hat" among the 11 members of his congregation for the purposes of building a church. By 1862, the Sutter Creek Methodist Episcopal Church had been built in the Greek Revival style. This view of the church is after 1895, when the vestry was added. (Courtesy Carolyn Fregulia.)

This photograph of a multitude of little girls dressed in their finest white lawn provides a very good image of the Methodist church. It is unknown what event the girls were participating in, but based on the clothing, the photograph dates between 1895 and 1905. (Courtesy Amador County Archives.)

The Catholic church, with a small cemetery surrounding it, can be seen in this early view. The church was built in 1860 and 1861 and was the first in the city. Father P. Bermingham was one of the many Catholic priests to preach at the church. He came to Sutter Creek in 1879 and was, like many of his brothers, a native of Ireland. His residence on Spanish Street remains the same home the Catholic priest lives in today, over a century later. (Courtesy Ed and Margaret Swift.)

This interior view of the town's Catholic church dates to 1942. The original church burned once, probably in 1888 or earlier, and was rebuilt. An 1870s drawing of the church, which may date to before the building burned the first time, shows a much larger steeple with a stained glass rosetta window. On February 4, 1972, the church burned again but was faithfully rebuilt in accordance with the original floor plan, utilizing materials, such as stained glass windows and the front porch, salvaged from the second building. (Courtesy Amador County Archives.)

The intimate Trinity Episcopal Church was located just up Amelia Street from the Catholic grounds. This postcard image was probably taken between 1910 and 1940. Formed in 1897, the congregation built the church in 1901. It is now a private residence. (Courtesy Carolyn Fregulia.)

The earliest known class portrait of Sutter Creek Grammar School is this one from "1st Grade in the Sutter School" dating to May 25, 1884. Several children are named, not in any particular order, and include J. T. Chandler, Annie Connors, Mamie Fagan, Mollie and Liz Collier, May L. Tibbits, Edith Kinsey, Mary Blake, Amilia Prignoli, and Lillie Kopp. Only Rose Green, in white on the far left of the second row, is identified. May Tibbits's father ran the town's first foundry, and Mamie Fagan's father was across Main Street with Fagan's Livery. (Courtesy Ed and Margaret Swift.)

A decade later, the top image shows a class from 1893. The bottom image, *c.* 1894, shows the Sutter Creek Grammar School "5th Room" class, as indicated on the slate held by the girl in the center. (Courtesy Amador County Archives.)

One early image of the Sutter Creek Grammar School shows the school prior to the 1896 addition of wings on the back of the building. The school district raised $5,000 in bonds to do the work, which also included adding a sewage system. The image was taken by Young and Werner photographers of Sacramento and captures the fairly large student body, which ranged from 200 to 300 students. (Courtesy Amador County Archives.)

Another early image of the school captures the children in posed play. Many of the little girls are dressed in their best Sunday whites, something that no mother would have dressed her child in on a normal school day. This image was taken very close to the time when the schoolhouse was expanded. (Courtesy Ed and Margaret Swift.)

With the addition of wings on the rear of the building, a new front porch, and a fresh whitewashing, the school is pictured here in 1905. It is easy to see why the building garnered praise as one of the finest schoolhouses in Amador County. The 1897 special mining edition of the *Amador Record* wrote: "The educational facilities of Sutter Creek rather excel those usually provided in mining communities." The headframe for the Wildman Mine's Emerson Shaft can be seen in the background to the right. It is a reminder that the children of these mining communities lived and played with the sound of stamp mills pounding 24 hours a day. (Courtesy Amador County Archives.)

This postcard was sent by one of the students, Tilden, to Miss J. Cavanagh in Petaluma in 1911. Tilden writes simply, in newly learned cursive, "This is my school-house." This postcard was one of a series produced by the Morris and Siebe pharmacy. (Courtesy Amador County Archives.)

This view of Sutter Creek from the southwest captures the steam laundry and the Wildman Mine, among other prominent features. The whitewashed Sutter Creek Grammar School stands out on the hillside overlooking the town. The image used in the postcard was taken between 1898 and 1912. (Courtesy Amador County Archives.)

This photograph of the girl's basketball team, in uniform with their ball, is from 1908. From left to right are (first row) Elsie Hartwick, Vea Schneebley, and Lavina Wearn; (second row) Nettie DePaoli, Mary Trenman, Carrie Malatesta, and Inez Whitfield. With no high school, these older girls were taking secondary classes at the grammar school. (Courtesy Amador County Archives.)

May Day celebrations were held annually and culminated with a picnic on the school grounds. Dressed in their best white lawn, this photograph captures the girls posing c. 1913 in front of the maypole. More photographs of the May Day parade can be seen in the next chapter. (Courtesy Amador County Archives.)

In uniform, the Sutter Creek Grammar School Boys Band is captured in this image, likely dating to 1913. The band instructor is Lester Casagrande. (Courtesy Amador County Archives.)

Donated to the Amador County Archives by lifelong Sutter Creek resident Azalea Cuneo, this is a portrait of Russell Cuneo's first-grade class, c. 1922. To see a class portrait that includes Azalea Cuneo from 1924, see page 87. Notice the striking difference in the loose-fitting dresses worn here compared with the restrictive clothing their counterparts contended with just a decade earlier. (Courtesy Amador County Archives.)

This is a portrait of the fifth-grade class in the decade before the school closed its doors. Ground was broken in 1951 for a new grammar school, to be built on the lower playground. Though the new school was completed in the 1950s, the old Sutter Creek Grammar School held classes into the 1960s, at which time it was closed. (Courtesy Amador County Archives.)

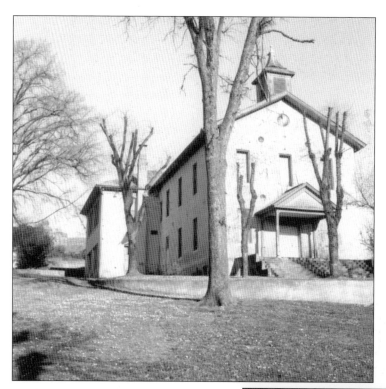

The schoolhouse, once the nicest in the county began to fall into serious disrepair after its abandonment in the mid-1960s. This photograph was taken by Clyde Berriman in 1967 and captures the quietness of a school yard without children. In 1976, the Sutter Creek Women's Club initiated a campaign to fund the restoration of the schoolhouse. That effort culminated a decade later when, on August 9, 1986, community leaders dedicated the restored building to the city. (Courtesy Amador County Archives.)

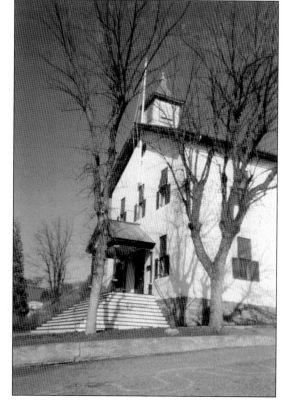

This photograph, taken in 1993, shows the restored schoolhouse looking much as it did a century ago. Today the building provides space for classes and clubs and houses the model railroader club's tracks, which would have delighted any of the children who once attended the Sutter Creek Grammar School. (Courtesy Carol Sethre.)

The Sutter Creek Women's Club was established in 1910, formed primarily for the purpose of generating support for a high school, which they succeeded in doing. The first high school classes were held in 1911 in a building on Church Street, loaned by George Allen. The school offered two four-year course options—either an academic course for those with aspirations towards college or a commercial course. The Amador County High School basketball team, *c.* 1912, stands in front of the temporary high school. (Courtesy Amador County Archives.)

The new high school was dedicated as Amador County High School in 1914. Enrollment that first year was a grand total of 28 students, with two teachers presiding. John Curtis was the school's first principal. By the 1920s, enrollment was over 140 students. This postcard shows the cornerstone being laid in 1913, and it appears to be quite a social event. (Courtesy Amador County Archives.)

Sutter Creek loved to celebrate, and what better cause to parade than the dedication of the new high school on April 14, 1914. The dedication was especially gratifying to celebrate after a long rivalry with Jackson ended with Sutter Creek successfully winning the bid to locate the new high school in town. (Jackson, not to be outdone, disregarded the vote and built its own high school.) Here Macabee's car is splendidly decked out for the occasion. (Courtesy Amador County Archives.)

Likely dating from the early 1920s, in this image the Sutter Creek High School truck has "Just arrived from Plymouth, Amador City, and Drytown." Don Wilds, Ed Tippitts, John Bovinich, and Anna Lubenko are named as being on the truck but not identified. (Courtesy Carolyn Fregulia.)

Here are two images dating to the first years of Sutter Creek Union High School, located at the top of Spanish Street. Donald Jarvis was the first graduate in 1913. The school had 58 students and five teachers, with plans to add additional classes on agriculture, cooking, sewing, and shop work. The principal was John G. Curtis, and Miss Maude Taylor was the vice principal; both also taught classes. (Courtesy Amador County Archives.)

This *c.* 1930 image of the Sutter Creek Union High School football team identifies the players. From left to right are Tony Pinelli, Henry Ghiglieri, Rudolf Benedetti, Primo Pinotti, Nick "Capt. elect," "Hossman," Ely Kizich, Willis Keyes, Red Williams, Barney "Captain," and Shorty Lucob. (Courtesy Amador County Archives.)

With the field conveniently located next to the main building, football players for Sutter Creek Union High School play Vacaville for the Northern California championship, *c.* 1934. Sutter Creek won 26-6. The original high school building was demolished in 1975. (Courtesy Amador County Archives.)

Six

PARADES AND PICNICS

If the years approaching 1900 were the heyday for mining around Sutter Creek, so too was it for celebrating. Nothing showed off a community's pride more than a parade, and when followed with a picnic, life was perfect. May Day was celebrated, everything from Italian heritage to Odd Fellowship was feted, and gold rush history was relived on floats and horseback, all with school bands and the mayor on parade. Children were decked out in costumes, parents became miners and saloon girls for an afternoon, and those who didn't march participated from the tall sidewalks lining Main Street.

There must have been an incredible expenditure of time spent sewing and hanging red, white, and blue bunting for the Fourth of July, creating the variety seen in the city's arch over Main Street's Little Humbug Hill, and attending to the details of floats and costumes. All this dedication belied a pride of community and an awareness of the town's unique history as a player in the gold rush.

Baseball, barbeques, dances, memorials, and clubs played an active role in supporting communities within communities. There was a practical side to all the fanfare: businesses had the honor of sponsoring a float, saloons and dance halls opened their doors to thirsty revelers, and one could show off new babies and, in some cases, new wealth in polite society. The difficulties of life, from the dangers facing miners to the economic hardships, could be forgotten for a time in the festivities.

A few of the faces contained in these photographs are identified; many more remain unknown, though perhaps there are readers who recognize a parent or grandparent. This chapter celebrates Sutter Creek and citizens beyond its limits, parading their lives, accomplishments, and history for an appreciative audience. The Fourth of July was met with special fanfare, and the centennial celebration of 1876 was purported to be wildly celebrated in Sutter Creek. To this day, Sutter Creek still parades and picnics on the Fourth with a children's parade. Of all the parades Sutter Creek has seen pass its old buildings, the Italian Picnic Parade has been the longest running. The Italian Benevolent Society celebrated its 125th year in the summer of 2006 with its annual parade down main street, reminding us of traditions that are as deeply rooted as California is itself.

This *c.* 1887 photograph shows the Sutter Band on parade in front of the Keyes-Voorheis family home (left) and the Brinn house (right). This image came from the personal collection of M. D. Nixon, proprietor for many years of the American Exchange Hotel. This is one of the earliest photographs of this subject matter. (Courtesy Amador County Archives.)

This image, taken on September 6, 1906—Admission Day—shows the Main Street of Sutter Creek wonderfully beflagged and fancied up. The flags draped across Main Street proclaim "welcome" and bear both the Native Sons and Native Daughters of the Golden West logos. The Dennis Drug Company Store can be seen on the left. The main building on the right, with the double balcony, is the American Exchange Hotel. M. D. Nixon was the proprietor at the time of this photograph. The balcony was removed in the 1930s in an effort to modernize the building; in 2006, the balcony was rebuilt, to return a focus of Sutter Creek's downtown core to its historic appearance. (Courtesy Amador County Archives.)

This is the first known image of the Sutter Creek Chapter of the Native Daughters of the Golden West, c. 1890. (Courtesy Carolyn Fregulia.)

This stereograph card shows two little boys, dressed in matching overalls and straw panama hats, walking along the dirt street in tune to the city's band. The Dennis Drug Company store (precursor to Morris and Siebe) and the American Exchange Hotel can be seen on the left in this image that dates to after 1897. Behind the boys, the American flag and another unidentified flag are respectfully carried. (Courtesy Amador County Archives.)

A celebration of the Odd Fellow Society with a parade shows one of the many arches that graced Sutter Creek's Main Street on Little Humbug Hill. This *c.* 1905 image captured a nice

view of the American Exchange Hotel, seen in the foreground on the left. (Courtesy Amador County Archives.)

Dating between 1890 and 1900, this photograph shows the Sutter Band playing at an Italian Benevolent Society annual picnic, parade, and program. (Courtesy Amador County Archives.)

Edith Steel, her hand on a child's cradle, smiles to the unidentified photographer from her parade float over a century ago. The theme of this float was "the hand that rocks the cradle rules the world." Two little girls are hidden among the corners of the float in this c. 1900 photograph. (Courtesy Amador County Archives.)

Parades were not the only cause for a celebration and picnic. This image is of the Valley Brew Baseball team of Sutter Creek from the 1890s. Lorenzo Cuneo, center holding paper, was the manager. Each community had at least one baseball team—some more than one—and it was quite the social event to watch the teams play. (Courtesy Carolyn Fregulia.)

This image depicts the Sutter Baseball team, also of Sutter Creek, in the 1890s. Conflicting information indicates who is on the team, but it likely consisted of R. F. Davis, the Fontenrose brothers, a Tibbits and/or Donnelly, Will Orchard, O. Boyle, Frank Mails, a Dr. Gabbs (and perhaps a Bill Benardis too.) (Courtesy Amador County Archives.)

✸ GRAND BALL ✸

—TO BE GIVEN AT—

Levaggi's Theater, Sutter Creek,

SATURDAY EVENING, SEPTEMBER 9,

—Under the Auspices of—

**SUTTER CREEK LODGE, NO. 31, I. O. O. F., and
AMADOR PARLOR, NO. 17, N. S. G. W.**

TICKETS ✸ TWO ✸ DOLLARS.

Supper Served at Exchange Hotel at 50c Per Plate

—GRAND—

...Outdoor Ball...

—AT—

SUTTER CREEK,

—ON—

Wednesday, July 4, 1900.

FLOOR DIRECTOR - - F. M. MORRISH.

FLOOR MANAGERS:

JOSEPH RIESTRA, SUTTER CREEK; LAWRENCE BURKE, PLYMOUTH;

P. JONAS, VOLCANO;

P. DABOVICH, AMADOR CITY; CHAS. C. GINOCCHIO, JACKSON;

FRANK HAVERSTICK, IONE.

AMADOR RECORD PRINT.

Dances were another reason to celebrate and dine. The ticket above is for an event at the Levaggi Theatre, an opera house built on Main Street in the 1890s. Supper was included at the American Exchange for a mere 50¢ more. The image at left is a dance card for the Grand Outdoor Ball, held for the Fourth of July celebrations in 1900. The floor director was F. M. Morrish, who had help from Joseph Riestra of Sutter Creek, along with a number of other responsible floor managers throughout the county. (Courtesy Ed and Margaret Swift.)

By 1915, the heritage and folklore of the gold rush was well ingrained in the lives of Sutter Creek's citizens. Celebrating in the May Day parade, the Provis brothers, Harvard (left) and John, were dressed as miner forty-niners, with the pet goat serving as a pint-sized pack animal. (Courtesy Amador County Archives.)

Another image of the May Day parade from 1915 shows children decked out for the parade along Spanish Street. From the same event (below), Bayra Richards is the queen. The horse's name, Dolly, has even passed down through time. (Courtesy Amador County Archives.)

May Day was also celebrated with a picnic at the Sutter Creek Grammar School. These images date between 1908 and 1911 and show the little girls on their floral throne. In the image below, the little girls are identified, from left to right, as Frances Soracco, Flora Darron, Sophia Obradavich (reigning as May Day queen), Lois Littlefield, and Mildred Allen. The last little girl is the mother of the photograph's donor. (Courtesy Ed and Margaret Swift.)

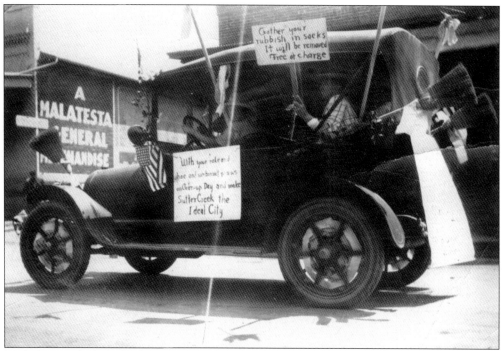

With their car bedecked in brooms, flags, and even crepe paper through the tire spokes, unidentified citizens create their own parade with a sign declaring, "With your rake and hoe and sunbonnet join us on Clean-up Day and make Sutter Creek the Ideal City." Note the advertisement for Malatesta's store in the background, c. 1920s. (Courtesy Ed and Margaret Swift.)

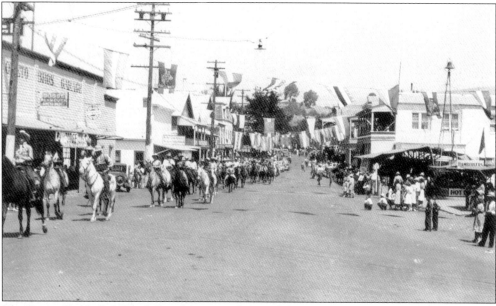

The Sutter Creek Gold Rush Parade, pictured above, along with a Round-up, were events held during Gold Rush Days. These celebrations were sponsored by the Sutter Creek Boosters to promote interest in the area—an early precursor to today's merchants' association. The parade's lifespan was brief, from 1937 to 1941. (Courtesy Amador County Archives.)

Gold Rush Days, celebrated between 1937 and 1941, was an idea that many of the town merchants developed to promote Sutter Creek as a destination place. The advent of the automobile changed Americans' pastimes dramatically, and as people began traveling for pleasure, the importance of tourism increased. This photograph was taken July 21, 1937, at a Booster's Club dinner at the Sutter Club Coffee Shop, the American Exchange Hotel with a modernized facade. Note the faux wood planking on The Tavern bar to the right of the hotel to help give it that "Wild West" appearance. (Courtesy Amador County Archives.)

Dressed as a miner, Hart Barker celebrates Gold Rush Days with his trusty donkey. (Courtesy Ed and Margaret Swift.)

Adele Tallia is the celebration's queen, drawn by a four-horse team at a Gold Rush Parade, most likely the first one in 1937. (Courtesy Ed and Margaret Swift.)

The famous spaghetti dinners drew a line for hours, as captured in this image of the picnic part of the Italian Picnic and Parade. Here members of the Italian Benevolent Society are serving the hungry crowds, c. 1950s. (Courtesy Amador County Archives.)

Members of the Italian Benevolent Society are working on preparations for the famous deep-pit barbecue dinner, another favorite at the Italian Picnic, c. 1950s. (Courtesy Amador County Archives.)

More somber events took place at the "rock" in the circular grass park that divides Highway 49 on the south end of Main Street. Here Judge Ralph McGee, a World War I veteran, salutes (left, next to rock). Also present at the ceremonies was Norm Waters (far right), who later became a county supervisor and state assemblyman. A Memorial Day service was held regularly, such as this event in the late 1940s, and still is today. (Courtesy Amador County Archives.)

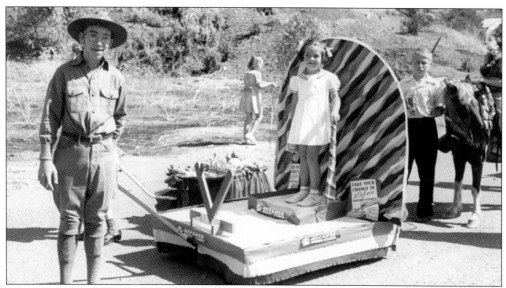

This little Boy Scout pulls his sister in a parade held during World War II. Their float is covered in wartime slogans such as "Take your change in defense savings stamps" and "Buy defense bonds and stamps." The war was especially difficult on hardrock mining communities, which experienced the closure of the mines during the war years. Gone for many was their primary employment, as most of Sutter Creek's mines did not reopen. (Courtesy Ed and Margaret Swift.)

Sutter Creek's children, including Olivia Sexton (left) and Sunday Baxter (right), are on parade, yet again, at the annual children's Fourth of July parade in 2004. (Courtesy *Amador Ledger-Dispatch*.)

REFERENCES

The following books, grey literature, and articles were referred to in the process of writing this book and provide a rich source for those interested in pursuing Sutter Creek and its gold rush history in further depth.

Carpenter, G. A., ed. *Amador Record Special Mining Edition*. Sutter Creek, CA: The Record Publishing Company, 1897.

Cenotto, Larry. *Logan's Alley: Amador County Yesterdays in Picture and Prose*. Volume I–IV. Jackson, CA: Cenotto Publications, 1988–2003.

Cenotto, Larry and Larry Schuman. *Italian Benevolent Society Centennial, 1881–1981*. Jackson, CA: Hanging Tree Publications, 1981.

Costa, Eric J. *Old Vines: A History of Winegrowing in Amador County*. Jackson, CA: Cenotto Publications, 1994.

Koeppel, Elliot H. *Sutter Creek, California: On the Gold Dust Trail*. La Habra, CA: Malakoff and Company Publishing, 2002.

Marvin, Judith and Grace H. Ziesing. *Historical Architectural Survey Report/Bridge Evaluation for the Sutter Creek Bridge Replacement Project, Highway 49, Sutter Creek, Amador County, California*. Rohnert Park, CA: Prepared for California Department of Transportation by Anthropological Studies Center, 2000.

Mason, Jesse D. *History of Amador County California*. Oakland, CA: Thompson and West, 1881.

Samuel Knight Chapter of the Society for Industrial Archaeology, et al. *A Strategic Plan to Preserve Knight Foundry*. Sutter Creek, CA: Save Knight Foundry Task Force, 1998.

Sargent, J. L., ed. *Amador County History*. Jackson, CA: Amador County Federation of Women's Clubs, 1927.

Across America, People are Discovering Something Wonderful. Their Heritage.

Arcadia Publishing is the leading local history publisher in the United States. With more than 3,000 titles in print and hundreds of new titles released every year, Arcadia has extensive specialized experience chronicling the history of communities and celebrating America's hidden stories, bringing to life the people, places, and events from the past. To discover the history of other communities across the nation, please visit:

www.arcadiapublishing.com

Customized search tools allow you to find regional history books about the town where you grew up, the cities where your friends and family live, the town where your parents met, or even that retirement spot you've been dreaming about.